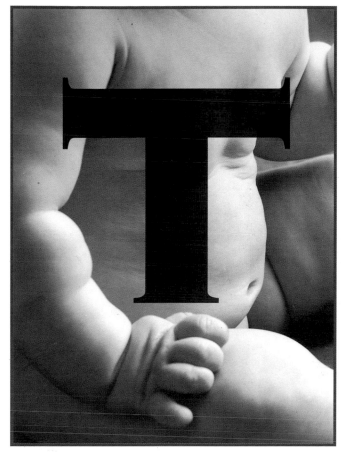

This book is for people who want to create stunning photographs of the babies they love with a minimum of effort and fancy equipment (a point-and-shoot camera will do).

Executive Editor: Elizabeth Viscott Sullivan
Editor: Tricia Levi
Production Manager: Rachel Cabrera

Designed & produced by Karen Engelmann
Luminary Books & Design, Dobbs Ferry, NY

Library of Congress Cataloging-in-Publication Data
Kelsh, Nick.
 How to photograph your baby : getting closer with
your camera and your heart / Nick Kelsh
 p. cm.
ISBN 1-55670-895-5
1. Photography of Infants I. Title.
TR681.I6K44 1999
778.9'25--dc21 98-37-599
 CIP

Published by Stewart, Tabori & Chang
An imprint of Harry N. Abrams, Inc.

Printed and bound in Hong Kong

10 9 8 7

HNA
harry n. abrams, inc.
a subsidiary of La Martinière Groupe
115 West 18th Street
New York, NY 10011
www.hnabooks.com

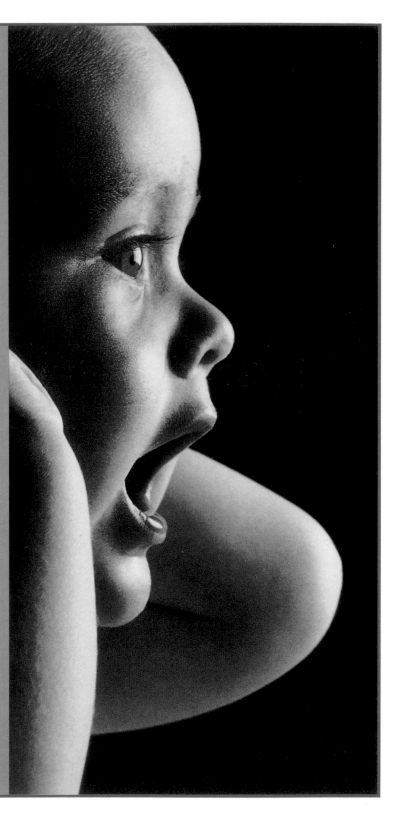

How to
PHOTOGRAPH
YOUR BABY

getting closer with your camera and your heart

nick kelsh

Stewart, Tabori & Chang
New York

I'm going to assume that most of you who are reading this book are parents, although I know that there are lots of grandparents, aunts, uncles, and friends who love certain children as much as any father and mother, and who will want to take beautiful pictures, too.

Except for an optional section, "A Little Advanced," there will be no technical photographic discussions included in this book. I'm sensitive to the fact that new parents are likely overwhelmed by dozens of other child-rearing details and are probably sleep deprived.

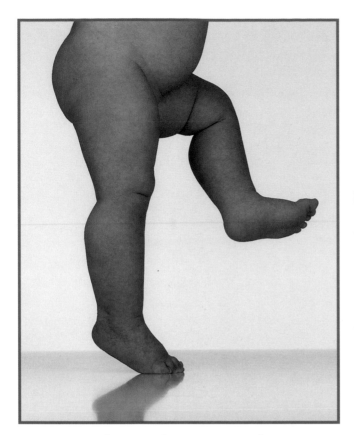

I can't imagine that you want to digest the relationship between flash ratio and ASA. For that reason, this is the last sentence in the book that will contain the terms "f-stop" and "shutter speed."

Nor is this a book of general photography lessons. If you want to learn how to shoot better pictures on your vacation or capture that peak moment of action as your daughter scores a soccer goal, you've come to the wrong place. What I provide in the pages that follow is a recipe for making beautiful baby photographs—that's it. Together we will try to record those incredible sights you see when you are alone with your baby. I am not going to turn you into a photographer, but I am going to hold your hand as you walk through one of the classic rites of parenthood—the photographing of the baby. If you follow the simple instructions in this book, your relationship with photography will be permanently changed.

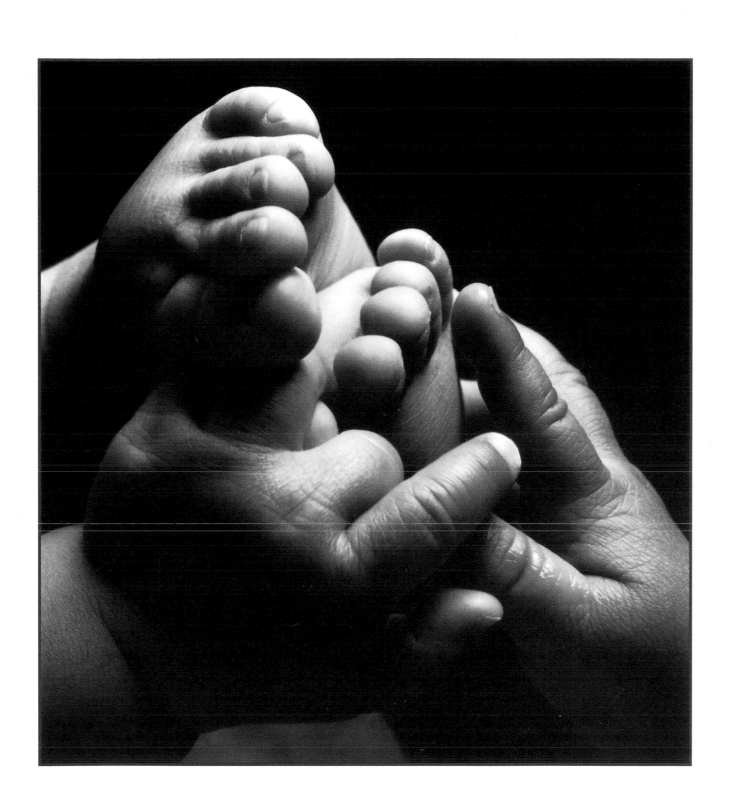

A NEW APPROACH

If you are an inexperienced photographer two approaches to producing baby photographs are within your technical grasp. One is the traditional snapshot and the other is through a basic photo session.

Snapshots are what most parents shoot all the time. Here's the course of events: their baby does something precocious or looks especially angelic, so parents fumble for the camera, point it, look for the shutter button, push the button, the flash goes off, and boom—snapshot. All this happens with very little consideration for aesthetics. This method is simple and limited and, in its own way, amazing. These modest photographs are among the first things people grab on their way out of burning buildings. The pictures produced by this method, however, generally leave the photographers feeling a little empty—they can't verbalize why, but their pictures just never look as good as what they saw in the viewfinder. (This has a lot to do with lighting and the flash, to be specific, but there's more on this in the "Turn Off That Flash" foldout.)

The subject matter in these pictures, however, and the love the photographers have for the subject—the most glorious child they've ever seen—carries the day.

Snapshots are priceless. I have drawers full of snapshots and I love them. But this book is not about snapshots. Most people have never considered another approach beyond snapshots. They assume that any greater photographic skill would require mastery over the mysteries of photography. Not true.

THE BASIC PHOTO SESSION

This is the approach I focus on in this book and it's one any amateur photographer can easily handle. For the purposes of this book, my definition of a photo session is putting the baby in beautiful light—near a large window or door to the outside—turning off your flash, and shooting more film than you have ever shot at one time, probably a hundred pictures in thirty minutes. The goal is to produce a few classic images that you and your baby will treasure forever. I know this works. I have watched some of my friends who are least competent with a camera make photographs that I would be proud to claim as my own.

There is a risk factor with the photo session, however. You have to be willing to take a lot of photographs at one time without hesitation. That costs money, although the cost of film and processing is a fraction of the cost of hiring a professional. I've had

people tell me that the whole experience, and shooting a virtually unlimited quantity of film, was liberating—there was no consideration of expense—and a lot of fun.

Good photography requires thought, but I am going to try to keep the thinking required by you to a minimum. To accommodate the schedule of newborn parents, this entire book can be read in one short sitting. If you plan your photo session carefully—that is, when you and your baby are both rested, no one is hungry, and when you're home alone—you are going to have a very gratifying experience. For one thing, people will comment on your surprising photographic skills. Beyond that, however, you will produce works of art that are visual statements of the feelings you have for this little person.

All you need is a decent point-and-shoot camera, some film, a window or a door, a plain background, and, of course, a baby you love.

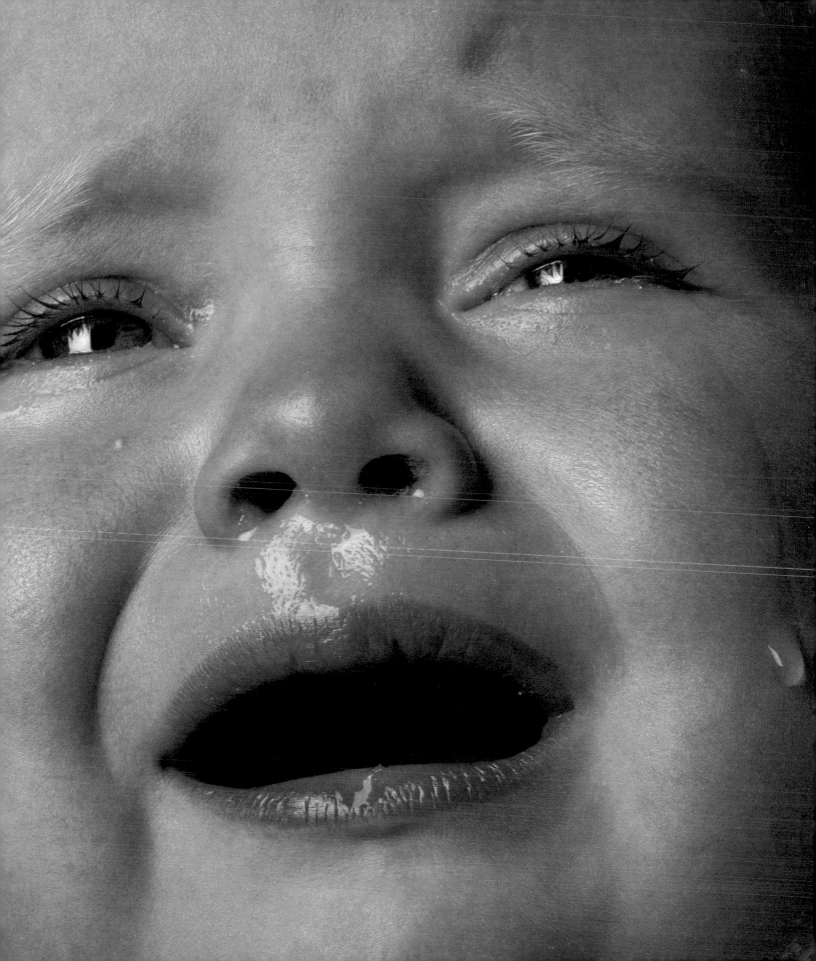

ON A PERSONAL NOTE

It strikes me as a little odd that I've written a book teaching people how to photograph their babies. Although Anna Quindlen and I recently co-authored *Naked Babies*, a book of essays and photographs celebrating the glory of babyhood, I've certainly never considered myself a baby photographer, let alone qualified to write a book about helping other people photograph their babies. And though it's true that I've been shooting photographs for almost thirty years and have certainly answered my fair share of questions from amateur photographers, I've never considered myself to be a photography educator.

But I'm probably as qualified as anyone can be. My credentials, however, have nothing to do with what kind of equipment I own or how many photographs I've had published in books or magazines. The expertise I have for this subject I share with every parent who has ever bought a camera, hoping to document the life of a new baby.

All any of us wants to do is create a memento of what our children look like at a given point in time. And if we follow our hearts, I believe we can elevate our snapshots to the level not just of family treasures, but family art.

When *Naked Babies* was published a lot of people asked me the same question: Why did you choose to do a book about babies? After all, my only child was already eight years old at the time. Diapers and drooling were way behind us, so why did I wait so long to do a book about infants? When the answer came to me, it seemed so obvious: I missed my baby. There are only a few absolute statements that can be made about babies and one of them, regretfully, is this—one day your baby, too, will grow up.

Photography is a miraculous thing. No painter can hope to compete with the lens in capturing natural beauty, and enabling us to witness history and view the solar system. I still stand transfixed as I watch an image appear through the murkiness of my darkroom. Although the combination of this wonderful medium and a naked baby is almost overwhelming, a photograph of Abraham Lincoln is always going to be more important than a picture of a toothless infant. But I still believe that the most precious photographs in the world are in the wallets and purses of parents.

I wish you the most loving photo session with your baby. I'm sure you will amaze yourself with the results and create something your baby's babies will treasure forever.

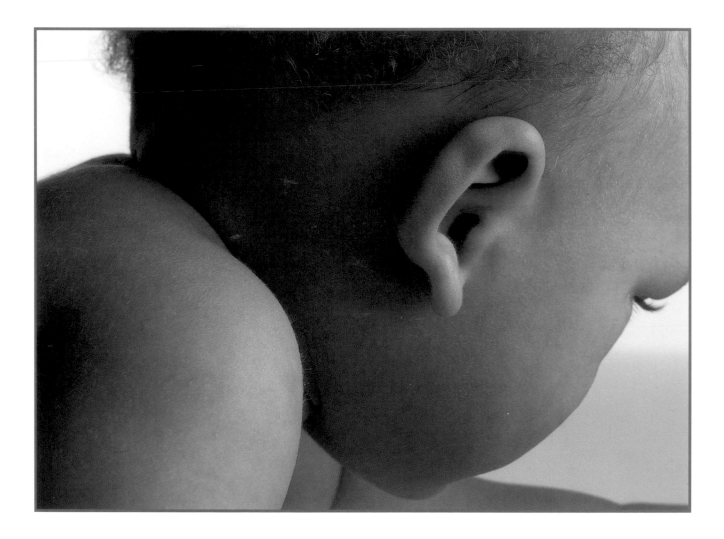

Contents

There are three basic ways to improve photographs that are described in this book—getting closer, shooting more film, and finding the right light. Of these, getting closer is the most important. Amateur photographers almost always stand too far away from the people they're photographing—often 10 to 20 feet from their subjects. And when the people are teeny-tiny, this is an even bigger problem because a baby from 10 feet away looks a lot smaller than a linebacker in your viewfinder.

Get close. Then get closer. It's that simple. I'm talking 2 or 3 or 4 feet here. It's even okay to crop off the top of your baby's head. You need to get as close as your camera will focus (an explanation follows in the "Focusing Close-Up" section of this foldout).

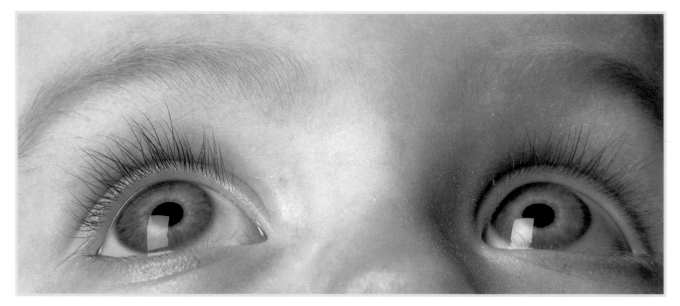

Because amateurs often stand so far away from the babies they are photographing, the babies get completely lost in the picture. They may be trying to get decent photos of their baby, but actually they're doing a marvelous job of documenting their living room. If you want a picture of your living room, fill the viewfinder with living room. If you want a great baby picture, fill the viewfinder with baby. Think of the photographic close-up as a visual declaration of what's in your heart.

More tips to help you get closer

USE SOME LOVING AGGRESSION

Most people's understandable resistance to getting closer has to do with insecurity. Photography is not just intimidating for the subjects. When you feel like you don't know what you're doing—in this case shooting photographs—it's difficult to do it with much aggression.

That's what I'm asking you to do—become lovingly aggressive with your camera. When you're getting close to your baby's face and you feel yourself becoming slightly uncomfortable, you're probably approaching the barrier that separates good baby photography from bad.

FOCUS ON FUN

If you loosen up you'll have more fun, and finding the humor in the situation will help you do both of these things. Behind the camera is an insecure, intimidated adult. In front of the camera is your baby—a defenseless, possibly naked, and yet totally liberated and uninhibited free spirit. Fortunately, the baby's indifference works only in your favor. Your baby absolutely couldn't care less how close you get with your camera much less what the final photo looks like.

TRY THIS SIMPLE FORMULA

Over the years I've photographed hundreds of children. Their parents often tell me that I've captured the child's personality or that somehow I was even able to put a bit of their soul on film. Of course, it's all very flattering—I smile sheepishly and thank them. What I don't tell them is this: these pictures are produced by following a simple formula. Here it is:

I place the baby in some flattering soft light—often so we are both sitting sideways next to a window (one side of the baby's face is light and the other is in shadow). I get the baby to look into the camera, though I don't necessarily try to get a smile. Then, I get very close.

With all due respect, Rembrandt built a career around this technique.

The photographs leave moms and dads thinking I possess some insight into the nature of childhood. Of course, I let them think that—I'm no fool—but trust me, it's a cheap photographer's trick. These seemingly perceptive portraits are nothing more than nicely executed close-ups in good light, and in the amateur world pictures like these are so rare they leap from the pack. Although it's just a trick, it works beautifully. The reason is this: The soft, flattering light—and the shadows that are produced—create strong emotion and mood. Nothing is more compelling to us than a dramatic look at another human face, and when that face belongs to your baby the impact is downright profound.

Professional photographers tend to have a cavalier attitude toward film. Shooting enough film—the lifeblood of photography—is so basic to successful picture taking that professionals don't even consider the cost. In fact, film is the last place professionals cut corners. They treat film like tissues—if they need more, they simply use more. If taking one more roll will let them sleep on the night after a big shoot—knowing they've done everything possible to get the very best picture—they will knock off another roll of thirty-six exposures with no hesitation.

Easy for them to do, you might say, it's not coming out of their pockets—clients or publications pay the expenses. That's true. And, you argue, they're competing in a cut throat business—they need to take it to the limit. True again. But without thinking, amateurs often take it to the other extreme—they simply don't shoot enough film. They act as though every frame on every roll is a priceless gem, as though they're scared to make any mistakes, which, of course, is a mistake in itself. Amateurs need to acquire the photographer's second most valuable tool—after a great set of eyeballs, that is. It's a relaxed shutter finger.

I compare relaxing your shutter finger to dancing. When you're really dancing—when you're really connected—you just do it. Neither partner wonders where they're going next. They just go there.

In photography, as in dancing, when you hesitate, you stumble. Spontaneous photographs require not just spontaneous events, but spontaneous photographers: photographers who don't think too much about when to push the shutter button. They just push it.

Thinking too much can get you into trouble. In the time it takes to think a thought, wonderful photographs come and go: The look of shock as a door slams; a baby's sneeze; the first blast of a sea breeze in a baby's face. Here, and then gone. Don't think. Just push the button. Dance with your shutter finger.

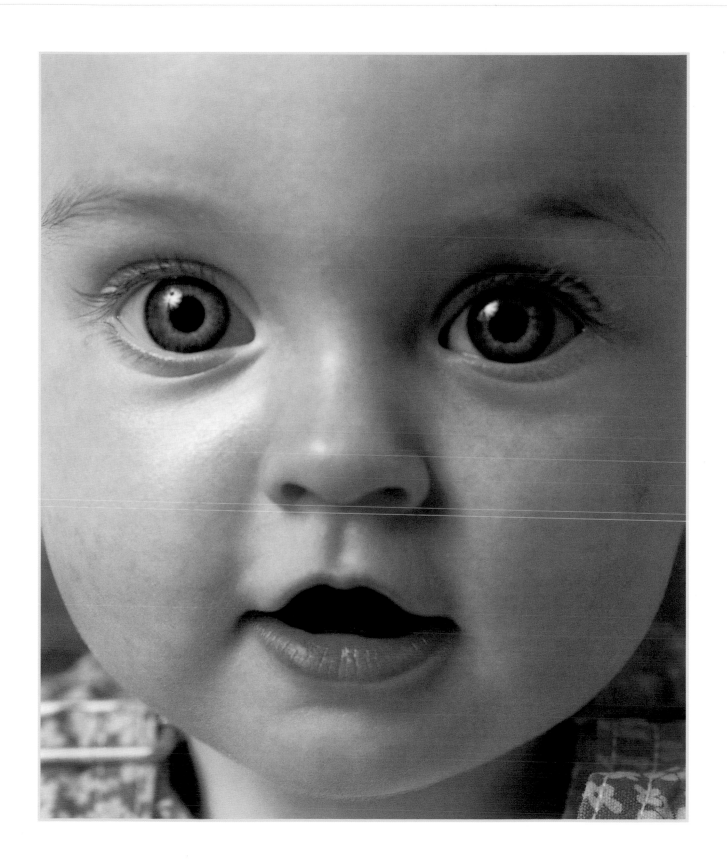

Most amateurs who purchase point-and-shoot cameras wisely buy one with a built-in flash. It was put there by a responsible camera manufacturer whose goal was to help you produce photographs easily. Having made that point, I realize the irony of what I'm about to say: That flash is destroying your pictures.

It's a curious statement, yet every professional photographer I know believes it. It has to do with what photographers call the quality of light. This is not to be confused with quantity of light—that is, how bright or dark something is. The sun has a large quantity of light and a cave does not. Quantity of light can be accurately measured with a light meter.

Quality of light is intangible. It has to do with emotion and mood—it can't be measured. The quality of candlelight is soft and beautiful. Just about everyone looks better in a room lit by candles. The quality of headlights is harsh and unflattering. On the quality-of-light scale your electronic flash is closer to the automobile headlight than to the candle. The quality of light produced by the flash on your camera is, to put it mildly, unattractive.

So when I say that the flash is destroying your pictures, I mean that it's keeping you from taking really beautiful photographs of your baby. It's the difference between professional work and amateur work. Professionals spend years developing the artistic ability to judge the quality of light and how it will reproduce on film; many amateurs don't know there's a difference.

I'm not silly enough to ask the parents of newborns to become sensitive to beautiful lighting overnight, but in the next foldout, "The Right Light," I'm going to show you specific locations where it always exists—you won't have to think about it. Then, try to find a quiet thirty minutes, turn off your flash, bathe your baby in this light, and experience the thrill of taking photographs you never thought possible. This section helps illuminate the reasons why flashes ruin baby photographs.

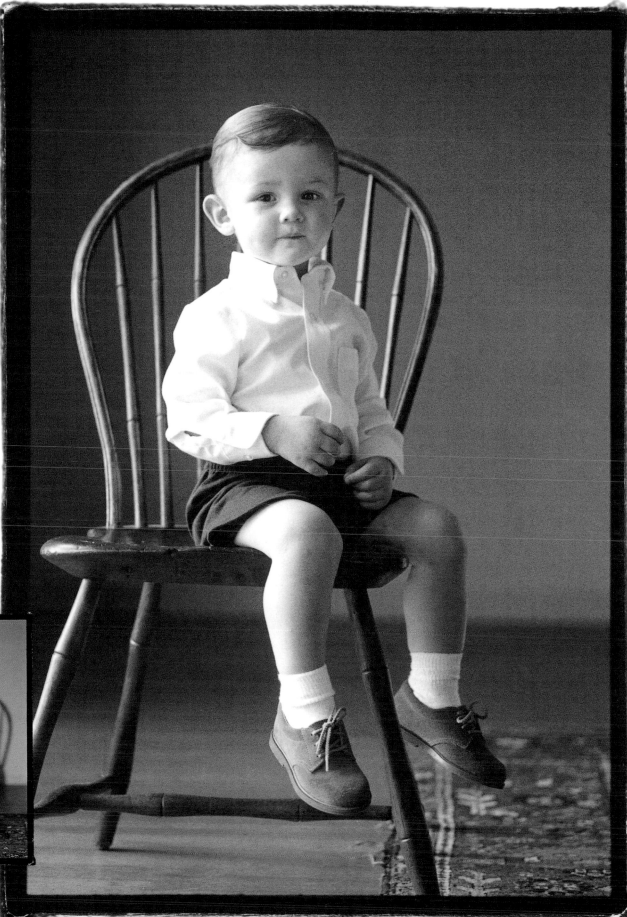

Evan
(light source: a door)

Evan was sitting next to a large patio door when these pictures were taken. They were taken less than a second apart, and yet one of them seems to say something about the spirit and mind of a two-year-old and the other one just feels like a snapshot—which it is. Notice how the flash lit up the background (photo below) *completely eliminating the mood of a little boy surrounded by the darkness. Exactly the same chair, exactly the same boy—the only difference is the lighting* (photo right, without flash). *Ironically, when we added light to the situation, the mood was completely destroyed.*

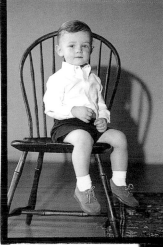

I make no pretense as to what is about to happen—we are going to steal from the master. If Rembrandt had written a set of instructions or drawn a map to guide us to beautiful light, it could not be any clearer than the directions he left us—he painted us pictures. Artists and photographers have copied his technique—using flattering, soft light to create dramatic shadows—ever since to produce stunning work. I don't know why we shouldn't do the same.

Just about everyone who sits in Rembrandt's light is transformed from just another face in the crowd to an artistic statement reflecting the essence of humanity. What makes this method so simple and elegant is that this light is everywhere. You don't need to leave home to find it. Just about every outdoor window, door, porch, alcove, or garage is a shrine to beauty. Your house or apartment has several locations waiting for a masterpiece to happen. I'll guide you to them.

Picture this: The sun is shining brightly. Sidewalks and streets and lawns are all reflecting the midday sun. Sunglasses are almost required. Someplace in your home is a room that's brightly lit by this reflected light from outside. Direct sunlight is not coming into the room, but the room is still bright and beautiful because it's so bright outside. Near the window or open door of that room is the light we're looking for. Hold your baby there so that one side of your baby's face is light and the other side is dark. It's that simple.

Remember, the light you're looking for is not direct sunlight. Direct sunlight produces hard-edged shadows. You're looking for soft light that is easy on the eye. The shadows it produces are soft-edged and gradual. You may think that there is absolutely nothing special about this light. After all, we are surrounded by it. That's actually a large part of the problem when teaching someone to observe it. It's so commonplace that we become jaded to its beauty—and some never see its beauty in the first place. But wait until you and your baby have a photo session in this light and you put it on film.

Your personal masterpieces await.

More photo ops

(ESPECIALLY FOR THOSE IN LIGHT-CHALLENGED LIVING SPACES)

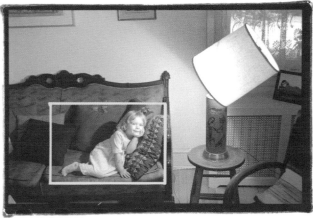

I realize there are many of you who may not have a garage or a porch, and for whom your front door opens up into a poorly lit hallway. I've lived in an apartment myself and there is no question about it—it's harder to find great light. But the situation is far from hopeless. You just need to be a little more flexible—and creative. Here are some suggestions that should help:

LAMP LIGHT

You can create dramatic light in your apartment by using a lamp with a lampshade. Put a bright light bulb in a lamp—100 watts is good—tilt the lampshade so the light shines toward the baby. Move the lamp close to the baby and off to one side (see photo at left). You may want to do this while your child is sitting in a high chair so he or she can't grab the lamp and tip it over. The color produced by a lamp is warmer—or more orange—than light from the sun. Warm tinted portraits such as those you'll produce with lamplight are beautiful—so don't worry about using this "artificial" light.

DINER LIGHT

Whenever I'm sitting at a window seat in a diner, I'm aware of the beautiful light on the faces of the people across from me. Aside from serving up comfort food (the greasier, the better), diners are also great locations for shooting photos of your baby. Go mid-morning on a sunny day and find a window seat. The crowd will be thinned out, the light will be pouring in the window, and if you get the right waitress, she will even help hold your baby's attention.

TRAIN LIGHT

Pictures of babies looking out of windows are almost always compelling—it's a classic situation that seems to capture their natural curiosity. Taking your camera on a train ride with your child could really pay off. There's plenty to hold their attention out the window and the light is constantly changing. The biggest problem is the shake of the train when the train pulls in for a station stop.

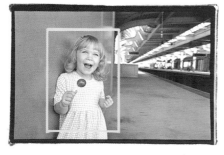

IT'S HARDER TO FIND GREAT LIGHT IN AN APARTMENT, BUT THE SITUATION IS FAR FROM HOPELESS.

A sense of humor is almost mandatory for successful baby photography because lots of unexpected things happen, and the only appropriate reaction is to laugh. I hope this section gets you loosened up and in the mood to have fun taking baby photographs.

A Foolproof Way to Make Your Baby Smile Every Time

It has been my experience that babies love to make people laugh. You can use this charming inclination to manipulate your baby into producing that Holy Grail of photography—the spontaneous baby smile. The loving ploy described here gives your baby his first gratifying laugh from an audience. I know it sounds strange that an infant could derive satisfaction from performing comedy, but if you know babies, the story rings true. Not only does the audience laugh, but the baby laughs—that's the point. If your goal is to photograph a very happy baby, this method always works. Guaranteed.

I generally recommend that people be alone with their babies for picture taking, but for this stunt, you need a small audience—about 3 or 4 adults or older children. You also need a set of keys (you should probably clean them). I have photographed many babies and I have never met one who wasn't fascinated by a set of keys.

How the Make-Your-Baby-Smile Ploy Works

First, get your camera ready—make sure there's film in it and that the settings are where you want them. Then, sit your baby down in beautiful light. Gather the audience around the baby. They may smile politely at your baby, but for maximum effect, they must not under any circumstances speak, particularly with any of those supposedly funny voices that adults use to entertain babies. After a short time, the baby starts to fidget. The photographer shakes the keys in front of the baby and, much to the baby's delight, allows the baby to play with them.

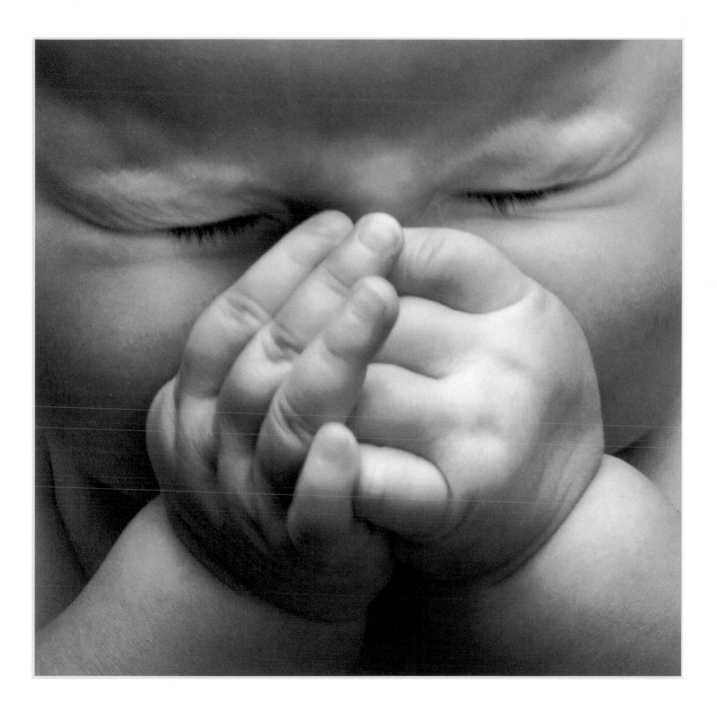

A BIG BABY SMILE ISN'T THE ONLY GREAT PHOTO.
BABIES CRYING AND DROOLING AND SNEEZING
ARE ALL WONDERFUL.

The photographer's most important piece of equipment is the heart—it's more important than any gadget in a camera bag or any helpful advice. I've never seen better evidence of this than in a story I heard not long ago. It's a tale about the loving use of photography. The actual photographs were taken with the most basic equipment. The film was processed at a corner drugstore.

This is the story of a father who began a tradition the week his son was born: He photographed his own hand holding his baby's. That was it. And every year after, sometime near the boy's birthday, he would repeat the ritual, filling the viewfinder of his camera with two hands, each of them slowly evolving over the years.

Neither of them ever brushed their hair or changed their shirts to produce a semblance of respectability. They were only photographing hands. In a quiet moment, the two of them would sit in the soft light of an open window and record the gradual effect of time on their bodies. And they did it in a way that fathers and sons rarely do—they held each other. Sometimes the fingernails revealed the effects of manual labor or the vestiges of fingerpaints. Now and then, a year was missed, and occasionally, a photograph was slightly out of focus or overexposed. But it didn't matter—the concept was perfect, and all the more so for its simplicity. Driven by the love of a man for his son, the results were nothing short of profound.

At first, only the son's hand showed the passage of the years. The father's stayed strong and proud while the smaller hand showed a youngster growing quickly into boyhood, then into adolescence. Then, the decades revealed themselves in the wrinkles and contours that crept into the father's skin. By this time, the son was the photographer, and his hands, gently holding his father's, had become the symbol of strength and protection. In the last of the series, a third hand—a granddaughter's—appears.

Wacky wigs and other funny ideas

There's certainly plenty of room for humor when it comes to photographing children. Just be open to the idea of doing something outrageous with your baby. My friend Kevin photographed his three-month-old daughter wearing different doll wigs. He carries these in his wallet and loves to pull them out with a straight face and watch how people react to them.

The picture below is the card we used at the holidays the year my son lost his front tooth. I used a fine point magic marker and blackened our teeth out on the print. I gave the print to my local photo shop and they made duplicate prints that we sent to our family and friends. It was that simple.

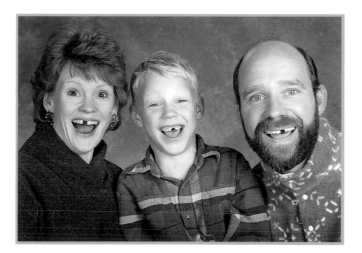

People often ask me if my son is the most photographed kid in the world. Considering my profession and his only-child status it's not unreasonable to think that I probably document his every milestone. The truth is, that's not even close. Several of our non-photographer friends shoot many more pictures of their children than I do.

But every Christmas there's a box under the tree for my wife containing three or four beautifully framed family pictures. These are the photographs from the previous year produced during family photo sessions. There's always a nice close-up of our son and probably a picture of he and my wife taken during our family vacation. Christmas is my annual deadline for adding to this collection of photographs displayed on a large table in our living room. My wife has actually hinted that I slow down production a little because we're running out of space. She's doesn't mean it, of course. She knows I'll never stop and hopes I won't. The pictures are too valuable. They give us pleasure all year long and everyone who comes into our home compliments them. They are family treasures.

The method I've chosen for showing off my pictures is covering a table top with them. Some people cover walls. Some people fill albums. Some people fill wallets. It doesn't really make any difference what you do as long as you show off your efforts in some way.

What makes my method work for me is that it's simple. I arrange three or four family photo sessions a year. I'll shoot a roll or two at one time. Shooting a whole roll of close-ups of my son in ten minutes isn't unusual. I do everything I can to produce great results. Another benefit of this approach is that I don't have piles of prints and negatives to go through at the end of the year. I save these photo session negatives in a fireproof box—and when I want to get my wife's Christmas gift together, there is only one place to look and only one trip to the framer.

BUT IF YOU DON'T WANT TO TALK ABOUT YOUR BABY, DON'T WEAR YOUR PHOTOS TO A PARTY.

show it off

REAL REFRIGERATOR ART

Do this and you'll have the best-looking refrigerator door in your baby group. It looks tricky, but it's really not that complicated. You will, however, need a lens that focuses quite close—probably about a foot. The goal is to produce one big photo mosaic that consists of sixteen small photos—like the pieces of a jigsaw puzzle. The finished product is perfect for a refrigerator door.

The first thing you need to do is focus your camera so that the viewfinder covers an area about 6 by 9 inches. Now imagine shooting sixteen pictures at that distance in a grid pattern that's four pictures wide and four pictures deep, because your 35mm camera takes rectangular pictures that will cover an area 24 by 36 inches. Picture that grid pattern laying over your baby when he's taking a nap—in other words, your baby is lying in the middle of the grid. Now start at one edge of the grid and shoot one row of four pictures. Then work your way back down the other row—like mowing the lawn. Don't worry if the edges don't line up perfectly. In fact, it's better if they don't. When you assemble the final photo overlap the edges and randomly angle the prints.

I reccommend doing this during your baby's nap because that may be the only time he will hold still for this activity. If you put the crib next to a window before the nap to take advantage of the wonderful light, you're going to have a great piece of kitchen art.

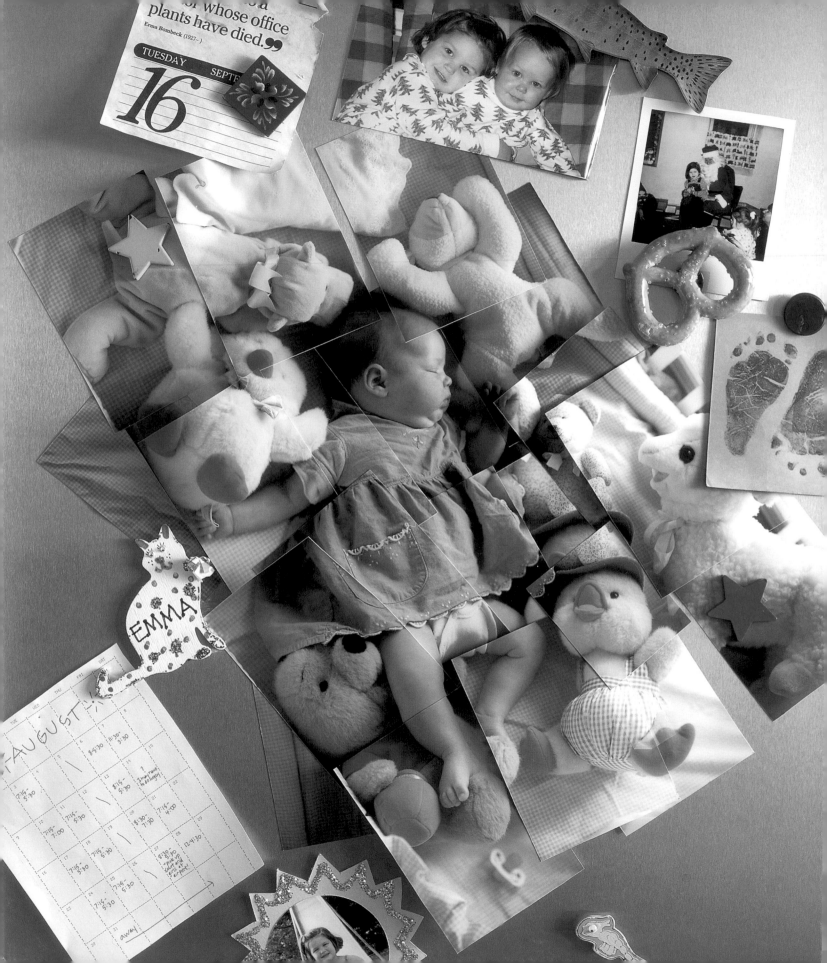

More ways to show off your photos!

BOTTOMS UP IN THE BATHROOM

No household with a baby should be without a naked baby-bottom photo in the bathroom. The more ornate the frame it's in the better. Very sweet and very funny. You will treasure this.

ELECTRONIC BABY

Many photo processing stores now offer the option of converting your photographs to a digital file. Instead of, or in addition to, getting regular prints you bring home a disc that allows you to view your photographs on your home computer. You can print them out or e-mail them, just like any other file. This is a fun,

high-tech way to send a photo to a loved one on the road—happy birthday, Mom!

IN YOUR POCKET

This photo wallet holds three 3 by 5 prints and stands upright when opened. It's thin and light—a great gift for someone who travels a lot.

BABY'S OWN ALBUM

Baby photos for babies—they love them. Many copy shops can do lamination and spiral binding for you. A simple photo album works, but when the pictures are laminated they've got the added advantage of

being completely drool-proof. There are all kinds of games you can play with this—Where is Anna's nose? Where is Anna's mouth? Which picture shows a smile? How many fingers can you find in this picture? The list is endless.

There are many similarities between making beautiful photographs and beautiful music. One of the most important is that regardless of how much you may want to produce great art when you get behind the camera or sit down at the piano, practice and natural ability—more than raw will—are probably going to determine success.

I know that some of you won't understand the importance of finding the right light or don't want to be bothered with it—it's just not worth it to you—and that's fine. If the only thing you've learned when you walk away from this book is that you need to get really close when you photograph your baby, it will all be worth it. Your baby photographs—and just about everything else you shoot—will be better for it.

Then again, there are those of you who have taken to what I've presented in this book like Van Cliburn to Chopin. The simple ideas I've shared probably strike you as good solid common sense and you're ready for more.

If you have some natural photographic talent and really exercise your visual muscles when it comes to lighting or composition, for example, you will give some pros a run for their money.

Included in this section are:
- Tips to help you set up a home studio, along with some of the tools you'll need.
- Simple techniques to use or mistakes to avoid that professionals take for granted. These "photography basics"—knowing when to use a telephoto lens and tripod, composing a photograph, and using black-and-white film—provide a solid foundation that gives their photographs a professional look.
- A few thoughts about how the rules of still photography apply to video. (They don't.)

Here's a friendly boost up the photographic ladder. I hope you enjoy the view.

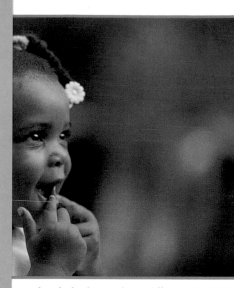

A LITTLE ADVANCED

UP TO

TRYING NEW

CHALLENGES?

READ THIS

SECTION.

...ctures but the backgrounds are different. The telephoto ...closer but to eliminate the background—a very smart

...he tripod down again. By the time you go ...oved again and you're back to zero. ...h too fluid for you to be anchored down ...not saying that there is no place for a tri-...t I am saying that there are certainly times ...e one. Photographing babies is one.

...OMPOSITION

...ers who would argue that you cannot ... composition—you either have the ...or you don't. On the highest levels I know ...amateurs make one very basic and, I ...andable compositional mistake that is ...medied.

The mistake is related to the use of the ...photographic term "shoot" for taking ...ameras today are point-and-shoots and ...omething you need to take aim. And that's

what ...
totally ...
smack ...
I ca...
high p...
perfec...
the wo...
If I ...
frame ...
So d...
The ...
sitively...
tradict...
ject's p...
when ...
which ...

*Same sit...
the hea...
right) the...
and the ...
ture is ...
become ...
says som...
subject is...*

mateurs do when they shoot photographs—they take aim. It's
rresistible for an inexperienced photographer to put their subjects
lab in the middle of the frame and, well, pull the trigger.

see it in their photography. Unfortunately, they are hitting a
rcentage of bull's eyes. Most of their pictures have the subject
y centered. I think there's a reason they call it *dead center*. In
ld of artistic composition, hitting a bull's eye is deadly.

ld you to never ever put your subject right in the middle of the
would be overstating my case and doing you a favor.

n't. Ever.

amera is a delicate tool of self expression and yet to use it sen-
requires some assertive behavior—photography is one big con-
on. You need to aggressively push the button, invade your sub-
ersonal space, move in closer and closer and closer, and then,
ou're finally close enough, compose lovingly tender images in
our subject isn't perfectly centered.

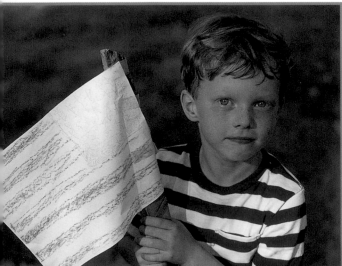

ation—two different feelings. With
dead-center in the frame (photo
picture lacks impact. With the flag
oy off-center (photo above), the pic-
ore compelling. The flag and boy
quals and the visual relationship
thing about the boy. An off-center
almost always more interesting.

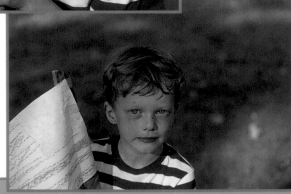

5. BLACK AND WHITE PHOTOGRAPHY

I love black and white photography. When I was 15 and obsessed with
photography, I dreamt in black and white.

An old high school friend visited me recently and when I showed
him *Naked Babies*—the all black and white book of baby pictures I
co-authored with Anna Quindlen—his first comment was, "Aren't you
ever going to buy a camera that takes color pictures?"

Well, all of my cameras "take color pictures," and I love color pho-
tography, too. But my heart belongs in the darkroom where the whites
and blacks and grays appear out of the red mist.

It's a color world, however, full of color images. Today's amateur
photo industry is built around color photography. I recently took
rolls of color and black and white film to a neighborhood proces-
sor. The color prints were ready in one hour. The black and white
took over a week—they had to send the film to another lab. It's
ancient technology and they were just not set up to deal with black
and white film.

However, black and white film is making a comeback in the amateur
market and it is, ironically, because of new technology.

The major film manufacturers are now producing something
called chromogenic film. That's a deluxe word for black and white
film that can be processed in regular color developer. That means
your lab doesn't have to send black and white film to another
processor. Now you can get your black and white pictures back in
one hour and they're beautiful. In the "Yes, It's Possible" foldout my
favorite photographs taken by parents were the
ones in black and white shot on chromogenic film.
But then again, I'm prejudiced. I love black and
white photography.

I would like to say a word of thanks to the
chemists who make this possible.

What about video?

Does the core advice I've given—get closer, shoot more film, and turn off your flash—apply to video cameras? It depends on your definition of "apply." In other words, not really. Do the opposite of everything you've done with your point-and-shoot, and you'll be fine. Here's what I mean.

1. GET CLOSER? DON'T.

Amateurs are zoom happy. It's just too much fun to push that zoom button and watch through the viewfinder as you float into tight face shot—hey, it was one of the reasons you bought the camera. But unlike your point-and-shoot still camera, home video cameras don't produce beautiful images. They do a wonderful job of recording information, however. And you will get more information in the picture with a wider shot.

Video is a great way to record what your baby's room looked like, for example. A two-minute walk through your house with the camera running—recording every room—will supply you with waves of memories in years to come. Of course, close-ups of faces are wonderful, but amateurs get stuck there and are slow to zoom back out. Think in terms of photographing action—blowing out birthday candles, playing with the new puppy, recording first steps taken. Still cameras have trouble competing with this.

2. SHOOT MORE FILM? BAD IDEA.

Turning the camera on and letting it roll until you become bored with the situation is a big mistake. If you thought it was boring the first time wait until you've gathered your friends and family to watch it again. It can be downright painful. Think in terms of short simple shots. If the situation you're videotaping is a little low on action—for example, your baby is playing with the stuffed animal your parents brought—make sure you pan the camera around the room and get nice reaction shots of Grandma and Grandpa watching the baby play. Then turn the camera off.

3. TURN OFF YOUR FLASH. LIGHT ISN'T A CONCERN.

I know, I know, video cameras don't have flashes. But because I've tried to raise your awareness of appropriate light, I need to tell you to not worry about lighting conditions when shooting video. With still photography the idea is to make beautiful images and for that you need beautiful light. It's not a consideration with video—the quality of the light is not all that important. With today's amazing video technology, virtually whatever light there is will be good enough. The one situation in which video cameras don't do well is with a subject in a dark area with a bright background, for example, a person silhouetted against a window with light shining in. The camera can't quite figure out how to expose properly. Beyond that, don't worry about light.

It seems unrealistic to present the work of a professional baby photographer as the standard of quality and expect amateurs to meet the challenge. And when the professional cheats, as I did, it's downright unjust.

Not all of the pictures I shot for this book were taken using the natural-light/no-flash method I prescribe. For some photos I used professional lighting equipment that produced results few amateurs could ever replicate in their homes.

All pictures in this section, however, were taken by people who played by the rules. They are not professional photographers—they're just parents interested in producing something more than the mundane snapshot. I gave each of them three rolls of film and asked them to shoot it all in a single session. They used the core advice in this book—get closer, shoot more film, and turn off your flash—and applied it to the pictures they took of their own babies.

They describe what they learned in their own words, but in the conversations I had with them afterward they all emphasized one point—shooting one hundred photographs of their babies in thirty minutes was not just fun, it was liberating because there was no consideration for expense. The luxury of making mistakes is a wonderful gift you can—and should—give yourself.

I thought it would be nice to show you the faces of the photographers and their subjects, so I asked each of them to come to my studio for a portrait. The passage of time reveals that where babies once were there are now little boys and girls.

The photos remain.

Is it possible to improve the quality of your photographs in a single photo session? Of course I believe it is, but let the viewer judge. Regardless of what you or I think, however, there wasn't a single mom or dad involved in this project who didn't love the photographs they took.

IF MY

NEIGHBOR

CAN DO IT,

YOU CAN DO IT.

AND MY

NEIGHBOR DID IT.

yes, it's possible

EVERYTHING YOU NEED TO KNOW ABOUT FILM... REALLY. EVERYTHING.

When I was in high school, I attended a speech by a well-known photojournalist. After he showed us his life's work—photographs of war, civil strife, and heart-rending images of the world's poor—he invited questions from the audience. I raised my hand and tried to impress him by asking, "What kind of film do you shoot?"

It is a question that amateurs can't resist asking; it's difficult for an inexperienced photographer to understand that the film a good photographer uses is not a large part of his or her success. "What kind of camera do you use?" is probably the second most asked question. I have been asked these questions hundreds of times over the years, and I always flash back on that moment thirty years ago. It's a question that usually doesn't have much relevance because great film does not necessarily make great photographs. However, in the case of shooting baby photographs with the flash turned off it is, ironically, critical.

What kind of film should you use for natural light baby photography?

The answer is fast film. Buy ASA 800 film—preferably from a well-known manufacturer. Some comes in yellow boxes. Some comes in green boxes. They are both technologically wonderful. ASA 800 film costs a bit more, but it's going to help you shoot sharper pictures.

Now the glitch. The salesperson at the photo store may tell you that this film is going to be grainy. This is true and false. Grainy is a relative term. It would be more accurate to describe ASA 800 film as grainier than ASA 100 film, for example. The bottom line: If you capture a beautiful baby moment on ASA 800 film you are not going to notice the grain. I have never heard an amateur photographer—or a professional, for that matter—look at a wonderful photograph and say, "Great picture, but it's a little grainy, isn't it?" It just doesn't happen.

It took me decades to come to the conclusion that the film a photographer uses doesn't matter. It's what's on the film that counts, and ASA 800 film is going to make it a lot easier for you to put what counts on film.

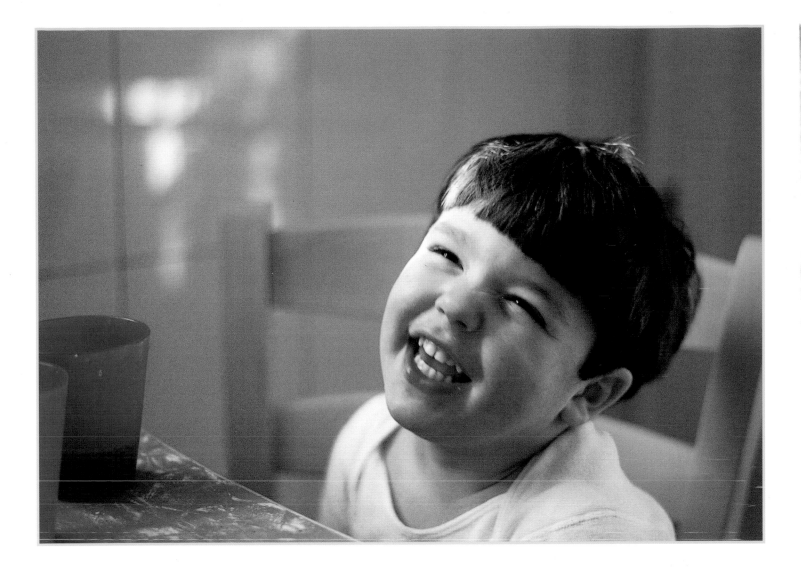

"This photograph captured a spontaneous moment at the kitchen table where the natural light was beautiful. I was much closer to Elias than I normally am when I take pictures. We just sort of made a game out of it—I got in closer, and he laughed. This is my favorite picture of Elias. I keep it over my computer."

MATTHEW BARTHOLOMEW,
FATHER OF ELIAS

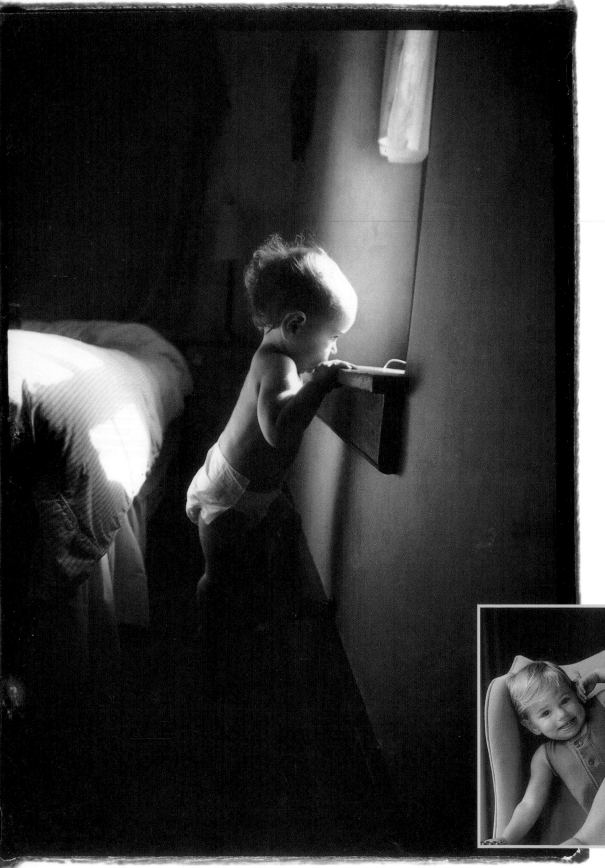

"I just couldn't believe how liberating it was to shoot all the film I wanted to. It was a blast. I got a lot more out-of-focus pictures than normal, but it didn't matter because I shot so much film—the ones that were sharp were much nicer than anything I ever did with a flash. I filled a large photo album with the photographs I shot in the one-hour session, and I absolutely treasure it. I shot black-and-white and color, but the black-and-white seems more artistic—it looks more professional."

**LISA NAPLES,
MOTHER OF
ISABEL**

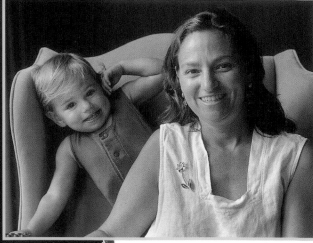

"When my daughter was born, I used ASA 800 film at the hospital. I had to deal with different types of light—including fluorescent and daylight—and for some reason, fast films seem to work better than slower films when you can't control the kind of light in the room. The color is better or at least more consistent. Fast films allow you to get a higher percentage of sharp pictures when you get this close. This is one of my favorite pictures of Allison."

FRANK GARBER, FATHER OF ALLISON

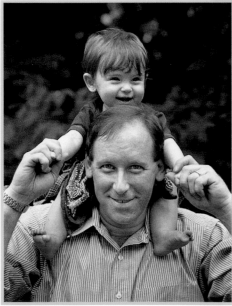

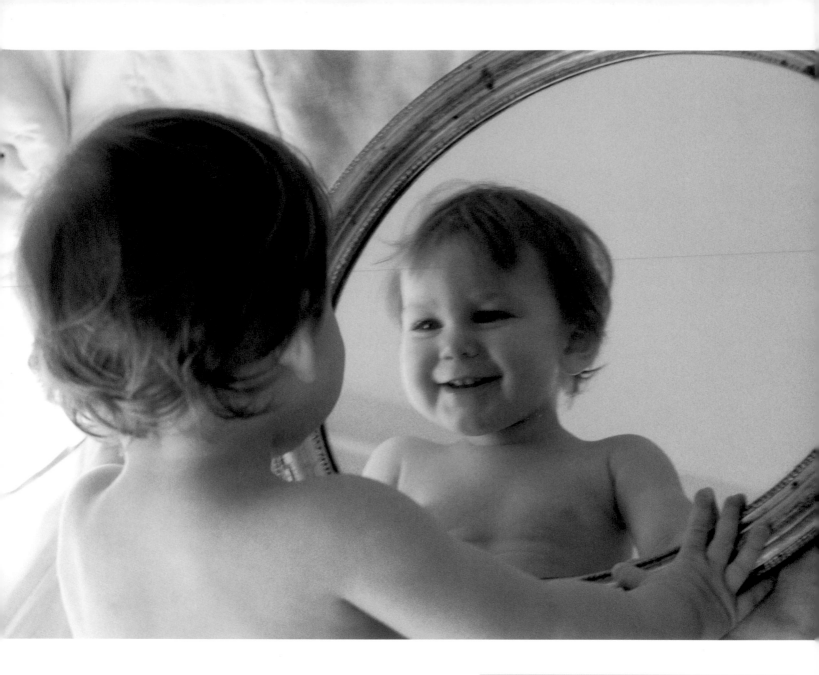

"The big thing was shooting all that film and not treating every picture as though it had to work. I could take chances, and it paid off. Some of my favorite pictures were just lucky, but I guess that's what professionals hope will happen to them when they shoot lots of film—that they get lucky. The result was that I had a lot of fun and got some lovely pictures of my daughter at a beautiful time in her life."

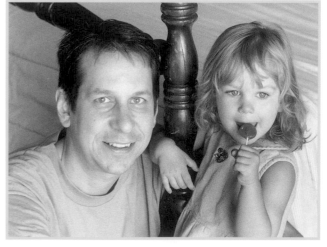

CHRIS SIMPSON,
FATHER OF MIMI

"I shot my photographs under a shade tree. The light was soft and beautiful, and I wanted to try some black-and-white. I got in so close that I cut the top of Kyle's head off in this picture. I remember reading somewhere that you should never do that, but I really liked it. I used this picture as a Christmas card, and I'm still getting compliments on it."

DAVID GRIFFIN, FATHER OF KYLE

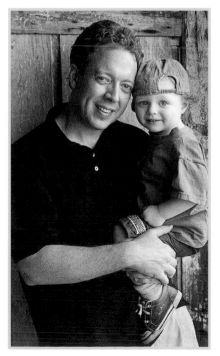

"It's become obvious to me that shooting lots of film is pretty basic to getting good pictures. Now I usually wait for a good picture-taking situation and then shoot twenty or more pictures. The overall quality of my pictures is so much better when I do this and it's a much more exciting approach to photography. My interest in photography in general has really increased since I started doing this."

KEVIN MONKO, FATHER OF OLIVIA

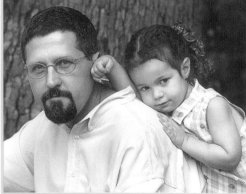

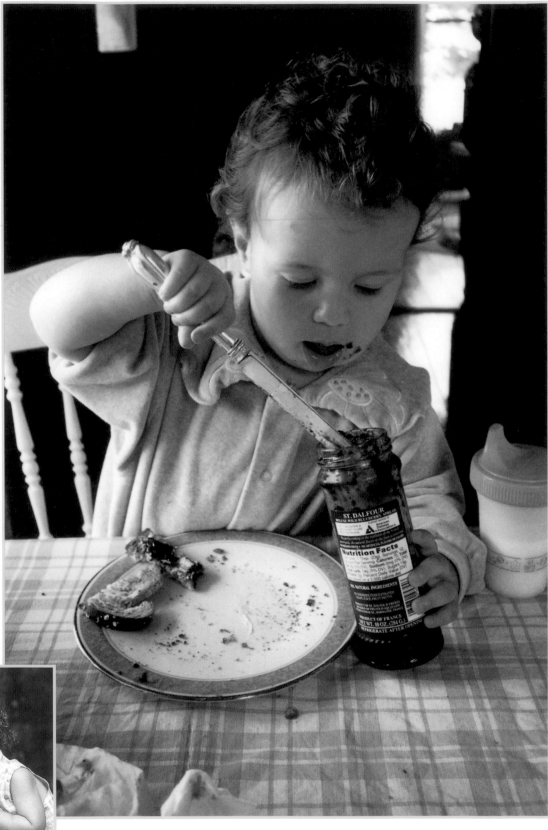

Create something your baby's babies will treasure forever.

NICK KELSH

THANK YOU

I would like to thank the following children for allowing me to photograph them, and in the process, brightening my life.

Elias Bartholomew, Spencer and Tommy Barton, Julia Boldt, Marques Bura, Emily and Thomas Cairns, Sam Conant, Michael Falduto, Allison Garber, Gina Gibson, Zahikaira Green, Kyle Griffin, Alexis Guido, Sophie Holman, Grant Richard James, Caroline Jones, Kadita Koita, Thomas Lennon, Jarod Adnan Louie, Benjamin Amadeus D. Malit, Isabella T.R. Martin, Chance Allen Melo, Miximillian Miller, W. Tate Miller, Olivia Monko, Evan Morgan, Isabel Naples, Paula Quon, Andrew Restrepo, Alyssa Kendall Ruehle, Isabel Schmidt, Claire Schmidt, Emma Schmidt, Lilah Jean Schrading, Eugene A. Shekhtman, Everette M. Simon, Mimi Simpson, Andres Esteban Soloalvarro, Siena Stroh, Lance Wertz, Asante Glen Williams, Michael Henry Williamson, and Samira Wilson.

Special thanks to Marta Hallett, Liz Sullivan, Tricia Levi, and Karen Engelmann. You were wonderful to work with.

The following people also contributed their time, knowledge and patience. My gratitude to them all.

Dick Bell, Ken Bookman, Lia Calhoun, Sharon Chantiles, John Conant, Marguerite Del Guidice, Geneva Dorman, Vernon Dorman, Barbara Guido, Wells Jenkins, Denise Jones, Bob Martin, Kevin Monko, Nell Moyer, Gabe Piser, Susan Romn, Court and Colleen Schmidt, John Sivello and everyone at Penguin Photo, Richard Smith, the staff of Kelsh Wilson Design, Inc., Professional Color in Philadelphia, and Rachel Cabrera and the rest of the staff at S Editions and Stewart, Tabori and Chang.

SOURCES

For the custom jewelry and holiday decorations featured in the "Show it off" foldout, contact:
Wells-Ware, P.O. Box 1576, New York, NY 10025
Phone: 212-222-9177, http://www.wellsware.com

Here's a list of some of the finest professional labs in the United States. They can solve just about any photographic problem, including the production of the enlarged contact sheet seen in the "Show it off" foldout. Any of them would be happy to help you regardless of where you live.

Professional Color
699 Ranstead Street
Philadelphia, PA 19106
Phone: 215-923-9700
Fax: 215-923-8500

Gamma Photo Labs
314 West Superior Street
Chicago,Il. 60610
Phone: 312-337-0022
Fax: 312-337-3753
http://www.gammaphoto.com

Infinity Color
3040 Lawrence Expressway
Santa Clara, CA 94105
Phone: 415-397-5057
Fax: 415-764-4967

Ivey Imaging
424 Eighth Avenue North
Seattle, WA 98109
Toll-free: 1-800-543-6273
Fax: 206-467-6297
http://www.ivey.com

Colourgenics Inc.
11 Davies Avenue, #101
Toronto, Ontario, Canada
Toll-free (Canada only):
1-800-265-7427
Phone: 416-461-3233
Fax: 416-462-9703
http://www.colourgenics.com
email: info@colourgenics.com

METRIC CONVERSION
centimeters = feet x 30

For Elizabeth & Cotten

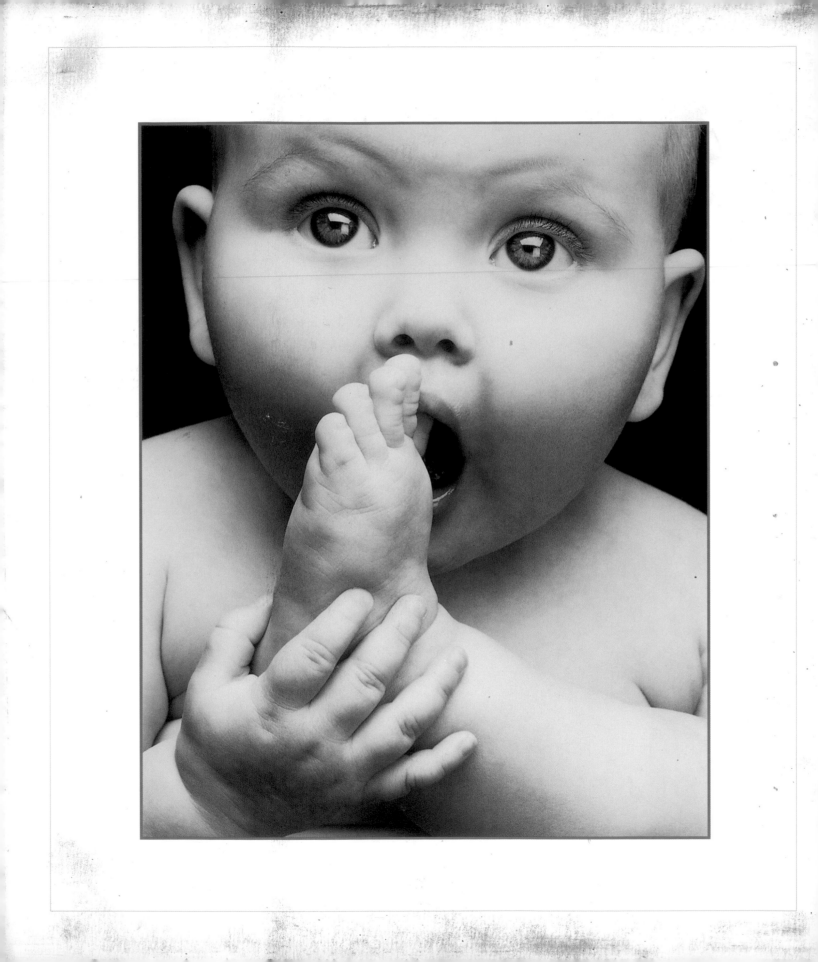